GW01454238

Published by Daoudi Publishing LLC
ISBN: 978-1-960809-22-3

Son
I Keep
Searching for
Answers...

Open Letter for Bereaved Mothers
A Memory Journal with Therapeutic Writing
Prompts for Emotional Healing After the Loss
of a Son

Evelyn Harrington

I Keep Searching for Answers Journals

TABLE OF CONTENTS

INTRODUCTION

By Evelyn Harrington

Grief is not just about loss, it's about learning to live with love that has nowhere to go. if you are holding this journal, know that whatever you're feeling is valid. the pain, the questions, the memories, and even the silence, all of it deserves space.

Losing a son changes everything. you may find yourself searching for answers, replaying moments, or wishing for words left unspoken. you may feel overwhelmed or unsure of what to feel at all. that's okay. grief isn't a straight path, and healing isn't about forgetting, it's about making room for what you carry inside.

This journal is here to support you, offering a safe space to express, reflect, and process at your own pace. the prompts inside will help you navigate loss, honor your emotions, and remind you that you are not alone.

Write when you're ready. be honest with yourself. your story, your grief, and your love for your son will always matter.

With warmth and understanding,
Evelyn Harrington

HOW TO USE THIS JOURNAL

There is no right or wrong way to use this journal. Some prompts may feel natural to answer, while others may be difficult. That's okay. If a prompt feels too heavy, you can:

- Write without stopping for one minute. don't worry about grammar, structure, or making sense. just let your thoughts pour onto the page, unfiltered.

- Pause and take a deep breath. give yourself permission to feel without judgment.

- Write from someone else's perspective. imagine what your son might say to you, or how a friend would respond to your emotions.

- Read the prompt out loud. saying the words first can help you process them before writing anything down.

IF YOU EVER FEEL STUCK, START WITH:

- Write down what you can answer today. if a prompt feels too big, break it down. answer just a small piece, and leave the rest for another time. some prompts may feel easier with time.

This journal is here for you, without expectations or timelines. Use it at your own pace, in whatever way helps you process your loss. Every word, every pause, and every tear matters.

This Journal Belongs To:

MY FAMILY TREE

"Family is like a tree, its roots keep us grounded, and its branches help us grow."

A LOOK AT MY SON'S LIFE

"A son may leave this world, but never his parent's heart."
— Unknown

My son's full name: _____

His birth date: _____

Date of death: _____

Where my son was born: _____

The job he was most proud of: _____

His favorite food: _____

A phrase or saying he always used: _____

His favorite song or artist: _____

A hobby he loved the most: _____

A place he always wanted to visit: _____

Things my son loved the most: _____

Things he absolutely couldn't stand: _____

His best quality that i admire: _____

One habit of his that always made me laugh: _____

Our favorite thing to do together: _____

His biggest dream in life was: _____

A lesson he taught me that i still live by: _____

Still My Son

The days go on, the seasons turn,

But still for you, my heart will yearn.

A smile, a spark, your favorite song,

A feeling that you're not truly gone.

Not every tear is filled with pain,

Some hold the warmth that will remain.

A sudden breeze, a distant drum,

A whisper soft that says, "I'm home."

Though time moves on and skies turn gray,

Your light still guides me through each day.

And in the hush of night begun,

I feel you near, still my sweet son.

DEALING WITH THE SHOCK OF LOSS

"The world is full of suffering. It is also full of overcoming it."
— Helen Keller

Dear son, ever since the shock of losing you, i've had a hard _____

I wish i could _____

I felt like everything around me _____

There was a moment when i felt completely numb, like _____

I didn't know what to do, so i just _____

I keep waiting for someone to tell me that _____

DEALING WITH THE SHOCK OF LOSS

"The darker the night, the brighter the stars."
— Fyodor Dostoevsky

It hit me the hardest when i saw_____

The first time it truly hit me that you were gone was when _____

I couldn't stop shaking when _____

I can still hear the words that changed everything:"_____

Grief has made it difficult for me to fall asleep, leaving me awake

with thoughts of_____

ACCEPTING THE TRUTH LITTLE BY LITTLE

"Painful things can't be forgotten. They can only be accepted."
— Unknown

Dear son, i keep telling myself this didn't really happen and _____

Some days, i still think you're just _____

I don't want to believe that i'll never _____

_____ again.

It feels like you're just away for a while, like _____

I still find myself reaching for the phone to _____

ACCEPTING THE TRUTH LITTLE BY LITTLE

"Denial is the shock absorber for the soul. It protects
us until we are capable of handling the truth."
— Unknown

It still feels like you'll walk through the door and say_____

I hear your laugh in my head and for a moment i think _____

I still talk to you sometimes like you're right here and i say_____

Sometimes i forget you're gone and start to _____

I pretend everything is normal when _____

A Special Moment Together

Place for Photo

Place for Photo

Place for Photo

A Space for Cherished Memories

SORTING THROUGH CONFUSING THOUGHTS

"Confusion is the beginning of understanding."
— Unknown

Son, i feel like i should know how to handle _____

I don't understand why _____

I'm confused about why _____

I wish someone could explain _____

I keep trying to make sense of _____

SORTING THROUGH CONFUSING THOUGHTS

"When you're lost in those woods, it sometimes
takes you a while to realize that you are lost."
— Patrick Ness

I thought i understood life, but now_____

I keep looking for answers about_____

Some days, i feel okay, but then _____

It feels like my emotions change every day because _____

FACING FEAR AND MOVING FORWARD

*"Fear has two meanings: Forget Everything And Run
or Face Everything And Rise. The choice is yours."*
— Zig Ziglar

Dear son, since you've been gone, i'm afraid that _____

Some days, i wake up afraid that _____

I'm afraid of facing _____

_____ because it _____

I worry that i'll never be able to _____

I keep thinking about the future and wondering _____

FACING FEAR AND MOVING FORWARD

"I learned that courage was not
the absence of fear, but the triumph over it."
— Nelson Mandela

I don't know what scares me more, missing you or _____

I wish i could hear you say, don't be afraid _____

I'm scared that life without you will always feel _____

Son, if you were here, i know you'd tell me _____

HANDLING ANGER IN A HEALTHY WAY

"Holding onto anger is like drinking poison
and expecting the other person to die."
— Buddha

Dear son, i get mad at myself when _____

I get angry sometimes when i see other people with their sons

_____ i wish i could _____

I never thought i'd be this mad about _____

It makes me mad that i didn't realize how precious _____

HANDLING ANGER IN A HEALTHY WAY

"Letting go of anger doesn't mean forgetting, it means choosing peace over pain."
— Unknown

I hate that i don't have _____

I just want you to know that even though i'm angry, i still _____

When people tell me _____

_____ i feel like _____

I know i should focus on healing _____

LETTING GO OF REGRET AND "WHAT-IFS"

*"Let go of what you think you should've done. You did
what you could with what you had."*
— Unknown

Dear son, i feel guilty that i didn't _____

I feel like i failed you when _____

_____ even though i know you'd _____

If I had just one more day with you, i would _____

I regret the times i was too busy to _____

I feel guilty that i didn't thank you enough for _____

LETTING GO OF REGRET AND "WHAT-IFS"

"Guilt is always hungry, don't let it consume you."
— Terri Guillemets

I wish i had listened more when you told me to:

• I worked on making _____

• I reminded myself that _____

• I held on to _____

• I learned to _____

• It was time to stop _____

• I needed to live _____

• I needed to trust that _____

• I tried to figure out how to _____

FREE YOURSELF FROM SHAME

"The less you talk about your shame, the more power it has."
— Brené Brown

Dear son, sometimes i feel ashamed because _____

I feel embarrassed when people see me _____

I know i shouldn't _____

If you were here, i know you'd tell me _____

I struggle to talk about _____

FREE YOURSELF FROM SHAME

"Shame dies when stories are told in safe places."
— Unknown

I avoid certain people because i'm afraid they'll think _____

Sometimes i catch myself lying about _____

I feel uncomfortable talking about you because i'm afraid people

will think _____

Even though i know you'd understand, i want to let myself feel

these natural feelings of shame and _____

I know healing means facing this shame, and i'm trying to

BREAKING THE SILENCE

"Speak your truth, even if your voice shakes."
— Maggie Kuhn

Dear son, even when we disagreed, i always hoped you knew

I wish we could go back to that day when _____

I'll never know why you couldn't say_____

I wanted you to see the real me when _____

_____ but i was afraid you'd _____

There were things i never said because i was afraid you'd _____

BREAKING THE SILENCE

"There is no greater agony than bearing an untold story inside you."
— Maya Angelou

I still question why you _____

I held back my feelings for so long because i thought you'd _____

I hope you knew that even in the worst moments, i still _____

I kept my struggles hidden from you because i wanted to seem

strong_____

I forgive you for all _____

Forever in This Frame

Place for Photo

Place for Photo

Place for Photo

A Collection of Wise Lessons

COPING WITH FEELING ALONE

"Healing begins when you realize you're not the only one who feels this way."
— Unknown

Son, since you've been gone, i feel so alone _____

I miss having you here when _____

Sometimes i sit in the quiet and pretend you're still _____

Since you left, i don't know who to turn to when i need _____

Some nights, i lie awake thinking about _____

COPING WITH FEELING ALONE

"The eternal quest of the human being is to shatter loneliness."
— Norman Cousins

Dear son, i feel invisible because no one seems to notice that _____

There are moments i wish i could call you just to hear you say

There are times when i want to talk to you so badly, but instead, i

just _____

I miss our conversations about:

- ◆ _____

- ◆ _____

- ◆ _____

- ◆ _____

- ◆ _____

It feels like the world has moved on, but i _____

MANAGING DEEP SADNESS

"It's okay to cry. It's okay to not be okay. Just don't give up."
— Unknown

Son, there are days when sadness follows me everywhere, especially
on the days when _____

Even when i'm surrounded by people, i feel the sadness_____

I find myself crying when i think about _____

Some nights, i hold my breath, wishing you'd _____

I wish i could call you right now and tell you _____

MANAGING DEEP SADNESS

"Let your sadness speak. Your heart has something it wants you to hear."
— Unknown

It hurts to think about the things you'll never get to see, like:

- _____
- _____
- _____
- _____
- _____
- _____
- _____
- _____
- _____
- _____

I know you wouldn't want me to be this sad, but _____

If you were here, i know you'd tell me _____

HOLDING THE MEMORIES

"There are places in the heart that can only be filled with memories."
— Unknown

Dear son, i miss the way you always knew exactly what i wanted

when _____

I still remember the days you bought me _____

_____ and _____

You always knew how to make me smile, whether it was bringing

home _____

_____ or _____

Son, i miss the way we used to drive around listening to _____

_____ and singing along to _____

and laughing about _____

I still remember the days we played _____

_____ until it got dark.

I still remember the times i let me stay up late watching _____

_____ and eating _____

and drinking _____ like it was a party.

HOLDING THE MEMORIES

"Sometimes, only one person is missing, and the whole world seems depopulated."
— Alphonse de Lamartine

You always made sure i felt special, even _____

I still remember how we sat together in the living room, talking

about _____ or _____

_____ or_____

_____ like there was no rush.

I still think about how i took the time to teach you how to fix

_____ making you feel capable and strong.

I still remember how i took you shopping and let you pick out

_____ and_____

_____ and _____

_____ even when you couldn't decide.

Son, i loved how we used to go on trips to _____

_____ and _____

_____ and _____

_____ always making the best memories outdoors.

Memories That Last

Place for Photo

Place for Photo

Place for Photo

Place for Photo

Moments and Things That Keep
Son's Memory Alive

FINDING SMALL MOMENTS OF PEACE

"The moment of relief is when you realize you don't have to carry it all alone."
— Unknown

Dear son, i know you're no longer in pain, and that brings me some

peace because _____

There's comfort in knowing your _____

Letting go of the pain doesn't mean letting go of you, and

i'm learning that _____

Knowing you're at peace makes it a little easier to _____

Even when i cry, i also feel relief _____

FINDING SMALL MOMENTS OF PEACE

"Relief often begins the moment you allow yourself to rest."
— Unknown

Son, i can finally sleep a little better knowing that _____

Sometimes, i close my eyes and feel you near, and that brings me

Even in my hardest moments _____

I take a deep breath and feel a strange sense of relief when

i remember that you're _____

I used to be so afraid of losing you, but now i realize _____

MAKING ROOM FOR ACCEPTANCE

"Happiness can exist only in acceptance."
— George Orwell

Son, i will always love you, but i am learning to live with _____

It's taken me time, but i finally understand that _____

I have learned to be grateful for_____

_____ instead of only focusing on what i've lost.

Even though i'll always miss you, i am _____

I used to think i couldn't go on without you, but now i know

MAKING ROOM FOR ACCEPTANCE

"Understanding is the first step to acceptance, and only with
acceptance can there be recovery."
— J.K. Rowling

Dear son, i am beginning to see that you will always be with me

when _____

I'm slowly learning to let go of what i can't change and _____

I'm starting to understand that love and loss can exist _____

I'm accepting that healing happens in small steps, like _____

I trust that my heart can hold both grief and _____

HONORING THE PAST WITH GRATITUDE

"Gratitude is not only the greatest of virtues, but the parent of all others."
— Marcus Tullius Cicero

Dear son even though you're gone, i am thankful that i can still

I am grateful for the strength you gave me, especially when i

Your kindness and wisdom still guide me when _____

I will always be thankful for the lessons you taught me, like:

◆ _____

◆ _____

◆ _____

◆ _____

◆ _____

◆ _____

◆ _____

◆ _____

HONORING THE PAST WITH GRATITUDE

"The more grateful I am, the more beauty I see."
— Mary Davis

I feel gratitude when i think about how much you _____

I appreciate the way you shaped my life by _____

Every time i think of you, i remember to be thankful for _____

I want to thank you for_____

◆ _____

◆ _____

◆ _____

◆ _____

◆ _____

◆ _____

◆ _____

KEEPING SON'S LOVE IN YOUR HEART

"The love we give away is the only love we keep."
— Elbert Hubbard

Dear son, i will always love you _____

One of the greatest gifts of your love was _____

I still feel your love when _____

I see the love you gave me reflected in _____

I carry your love with me every day, especially when _____

KEEPING SON'S LOVE IN YOUR HEART

"Where there is love there is life."
— Mahatma Gandhi

I hope i make you proud _____

Dear son, your love taught me how to _____

Your love still guides me when i have to _____

I think of you every time i hear_____

_____ because it reminds me of your love.

If i could hug you one more time, i'd say_____

A Photo of Love and Laughter

Place for Photo

Place for Photo

Place for Photo

Place for Photo

Place for Photo

Place for Photo

A Frame for Meaningful Advice

FINDING HOPE EVEN ON HARD DAYS

"Hope is being able to see that there is light despite all of the darkness."
— Desmond Tutu

Dear Son, i find hope in knowing that one day, i will _____

I am starting to see signs that things will get better, like _____

- ◆ _____

- ◆ _____

- ◆ _____

- ◆ _____

- ◆ _____

There was a time when i thought i'd never feel okay again, but now

Even on my hardest days, i remind myself that _____

FINDING HOPE EVEN ON HARD DAYS

"Once you choose hope, anything's possible."
— Christopher Reeve

I know you'd tell me to keep dreaming, so i will _____

I'm starting to believe that joy can exist alongside _____

Son, i will carry your lessons with me as i step into _____

I hope i can make you proud by _____

I am looking forward to _____

_____ because i know you'd want me to find joy again.

HEALING AND STRENGTH

"Growth is painful. Change is painful. But nothing is as painful as staying stuck somewhere you don't belong."
— Mandy Hale

Son, through this journey, i have learned to appreciate _____

I have learned about my own strength because _____

I never imagined i could heal in this way, but i am starting to

I have become more patient with myself and _____

Son, i never thought i'd be able to _____

_____ but now i realize i can.

HEALING AND STRENGTH

"Be not afraid of growing slowly, be afraid only of standing still."
— Chinese Proverb

I have realized that growth comes from: _____

My support system includes: _____

- ◆ _____
- ◆ _____
- ◆ _____
- ◆ _____
- ◆ _____
- ◆ _____
- ◆ _____
- ◆ _____

If you were here, i know you'd remind me that strength is _____

SELF-CARE WHILE YOU HEAL

"Act as if what you do makes a difference. It does."
— William James

To improve my daily life, i plan to focus on my sleep, meals, and

exercise, so i can _____

I plan to set a consistent sleep schedule by going to bed at _____

_____ and waking up at _____

To improve my sleep, i'll avoid _____

_____ before bed and instead focus on _____

My plan for improving my appetite is to start each day with

a healthy breakfast like _____

To boost my appetite, i'll try eating smaller portions of_____

_____throughout the day.

SELF-CARE WHILE YOU HEAL

"The journey of a thousand miles begins with one step."
— Lao Tzu

My goal for a balanced appetite is to include _____

_____ in my meals.

I plan to schedule time for sports activities like _____

_____ at least _____ times a week.

To make exercise enjoyable, i'll combine sports with fun activities

like _____

To improve my physical and mental health, i'll incorporate sports

such as _____

_____ into my weekly routine.

I plan to use sports as a way to manage stress by _____

_____ whenever i feel overwhelmed.

YOU ARE NOT ALONE ON THIS JOURNEY

(A GENTLE MESSAGE FOR BEREAVED PEOPLE)

"One kind word can warm three winter months."
— Japanese Proverb

You are not alone in this. we will find our way through this

grief, together and _____

You don't have to be strong every moment. some days, just

breathing is enough and _____

When the world feels like it has moved on, i want you to know

It's okay if you still expect to hear your son's voice or see them

walk through the door, this_____

You don't have to feel okay all the time, but when peace finds

you, even for a moment, let yourself_____

YOU ARE NOT ALONE ON THIS JOURNEY

(A GENTLE MESSAGE FOR BEREAVED PEOPLE)

"The best way to find yourself is to lose yourself in the service of others."
— Mahatma Gandhi

Some days, acceptance will feel impossible, and other days, it will feel like a quiet understanding. both are part of healing, just _____

You might feel lost right now, but i promise you, one day, you will find _____

Every memory, every lesson, every moment you shared is a gift that will always be yours. let gratitude be your _____

Even in solitude, you are connected to those who love you _____

Drink water, get fresh air, and find small ways to take care _____

A Memory Captured for Me

Place for Photo

Place for Photo

Place for Photo

This Is My Healing Story

Echo of You

The wind still sings, the trees still sway,

But something changed that final day.

A toy, a trail, your worn-out shoes,

Small things that say I still have you.

Not every silence breaks my heart,

Some gently hold the missing part.

A passing cloud, a flash of blue,

Reminds me I was loved by you.

Though you are gone, I feel it's true

The world still echoes parts of you.

And in that peace, both soft and wide,

I carry you, still by my side.

THE END

By Evelyn Harrington

Thank you for allowing this journal to be a part of your journey. If you've filled these pages, even a little, know that you have already taken steps toward healing. If you found yourself pausing, struggling, or needing to step away, that's okay too. healing is not about speed, it's about giving yourself grace in the moments you need it most.

I wrote this journal with the hope that it would offer you comfort, reflection, and a safe space to express what's inside. no words will ever replace the presence of the one you lost, but I hope you have found a way to hold their love close, through your thoughts, your memories, and your own path forward.

I Am Grateful to You

If this journal has helped you in any way, i would be truly grateful for your support. Leaving a review, sharing your experience, or recommending this journal to someone in need allows more people to find comfort and healing through these pages. your words have the power to help others, just as your journey has value in ways you may not yet realize.

With warmth and understanding,
Evelyn Harrington